FIRST EDITION

Managing Editor
Sarabande Books, Inc.
2234 Dundee Road, Suite 200
Louisville, KY 40205

www.sarabandebooks.org

Library of Congress Cataloging-in-Publication Data

Wright, Charles, 1935–
 Out-takes : sestets / Charles Wright.
 p. cm.
 ISBN 978-1-932511-86-4 (pbk. : alk. paper)
 I. Title.
 PS3573.R52O98 2010
 811'.54 — dc22

 2010002455

Design and layout by Eric Appleby

Manufactured in Canada.
This book is printed on acid-free paper.

Sarabande Books is a nonprofit literary organization.

The Kentucky Arts Council, the state arts agency, supports
Sarabande Books with state tax dollars and federal funding
from the National Endowment for the Arts.

Out-takes/
Sestets

CHARLES WRIGHT

art by

ERIC APPLEBY

POSTERITY

One tries, like a new jacket, one's absence on for size.
Always a tad snug,
One never finds, somehow, the proper fit,

 a 42 Regular.

And who will remember us when our days are short-armed?
And who will remember us

 in our ill-fitting duds,
Parked, in the back seat of the car, by the black river?

TOGETHER

I wish I had the capacity
 to see through my own death.
Some flash light, some force of flame
Picking out diamond points
 of falling leaves and the river of stars.

This is the year I'm scraping the ice away from its sidewalks.
This is the year I've slid its shoes off.
This is the year I've started to keep it company,
 and comb its hair.

MONDO APRILE

North grasses blue as sapphires,
Maples flourish green-threaded branches.
Like them my thoughts rise homeward,
Now that my heart remains south of south

 in scattered parts.

At night, in the spring wind,

 under the cascading cherry trees,
The last of their star-points fall and fall.

 — 李白

IN THE BEGINNING WAS THE WORD, IN THE END WAS THE WORD

Episiotomy. Now there's a word to settle down with.
And eschatology's another.
One out and one in,

 a slick highway, direction home.

My friend, however, says heaven is only for birds,

 for animals and trees,
And all the people will be in hell.
I'll miss the clouds a lot, and miss the moon,

 but I know he's right.

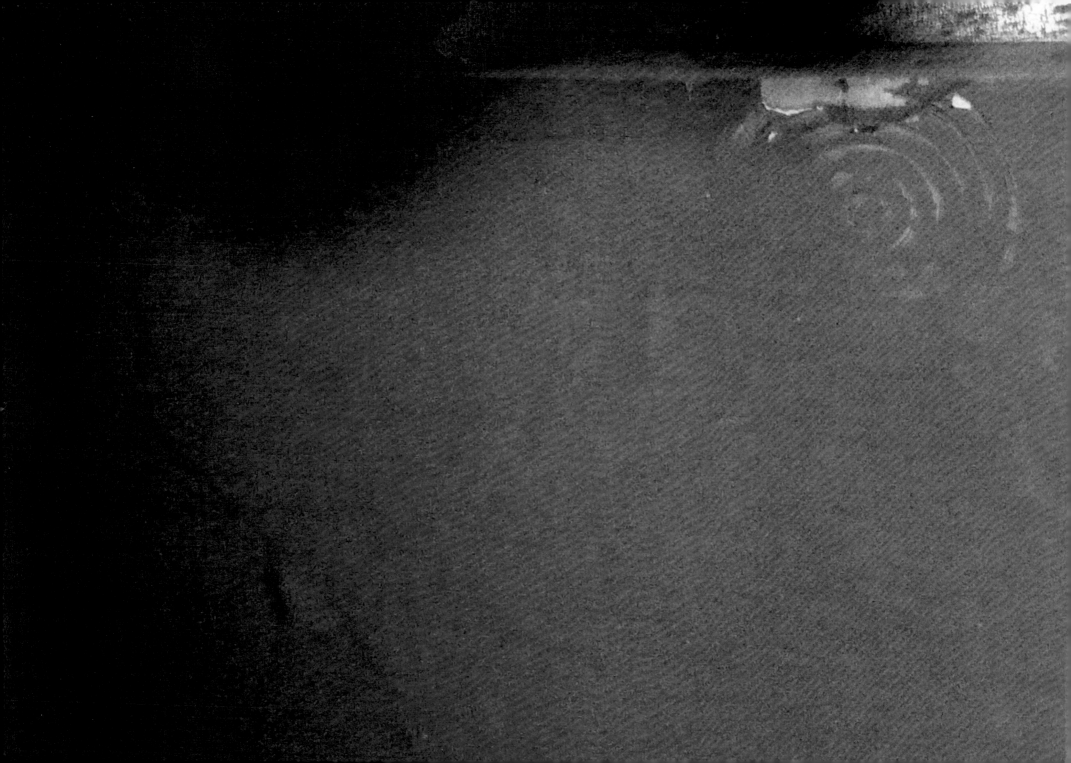

UNDER A NON-SHELTERING SKY

Beneath the tamarack and the lodge pole pine and the blow-down,
The twelve apostles scream in their sleep.
No one comes close to the wound,
 not even Thomas, the stout one.

It might as well be Jerusalem.
Instead, it's northwest Montana,
 Catholicism
Rampant among the limbs,
 sprinkles and white hands, filligree, filligree.

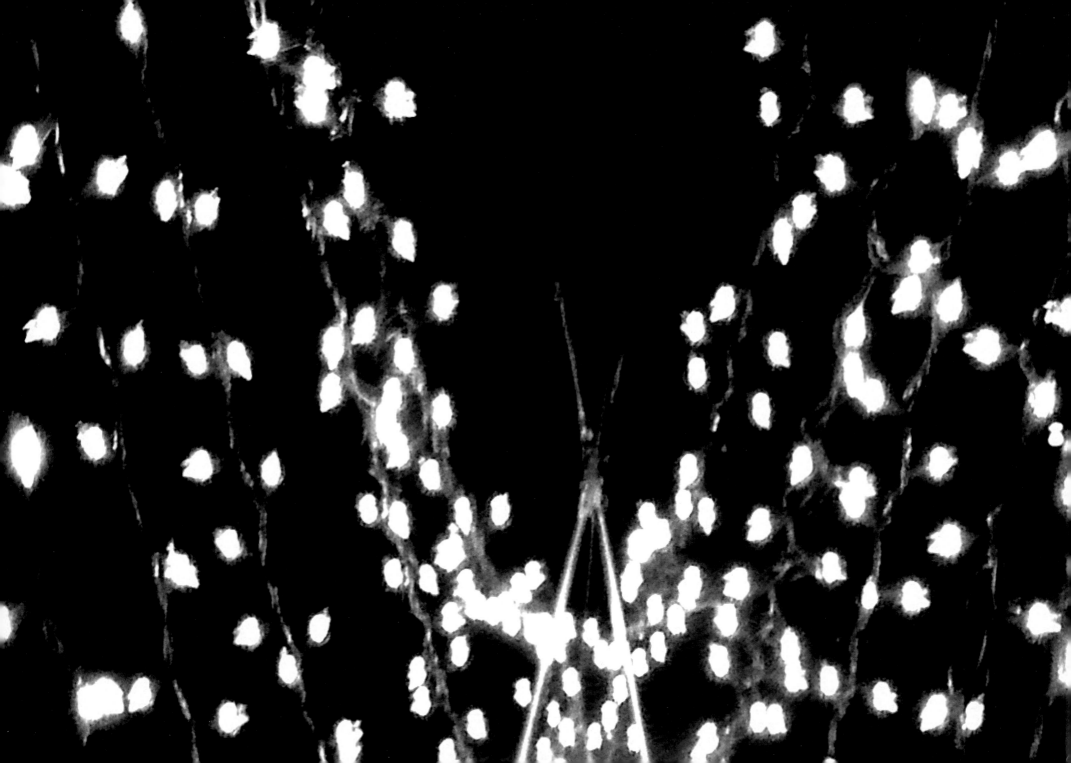

STAR RIDERS

One horse descends from another horse, or it doesn't.
Night nuzzles the sunlight's placenta
Before the darkness can drag it back in the woods
 and settle its hash.

Nature, raised under the sign of Cain, is cruel, but not mean.
Notice the distance in its look.
Notice the way the horses go on, and we do,
 from Norway to Katmandu.

THAT WAS THE YEAR WE WENT TO PONZA, I THINK

Ferragosto. Back in the day,
in Rome, in 1963,
 you could roll a bocce ball
From Piazza di Spagna to Piazza del Popolo

And not hit a moving thing.
A city of absences.
 Lord, where had they all gone?
Who knows, so far out of town we couldn't remember our own address.

NO ORGAN, NO SMELLS, NO BELLS

Thistledown floats in the air,
 some wind,
And thistledown floats in the air like little aspergilla,

Empty, and blessing no one.

The summer tugs at rot and ruin.
The creep of dun, and a dangerous dearth in the leaves.

The evening's pincher gathers the thistledown to its breastplate.

WEATHER REPORT II

Virgo soon into Libra, but
 some weeks down the road.
In September, the thunder stops, and the lightning too.
Grouse and the dove fly at their peril.

Well, we hope that the thunder stops, and the lightning is at an end.
No rainbows from here on out.
Summer is over, and autumn is icumen in.

IF YOU WALK IN HIS GOLDEN FOOTSTEPS, THE GOD WILL GET YOU

Ars brevis, vita brevis
As well, no way out.
The last time I saw this stalker,

 the half moon, I mean,

We were both in Montana.
Now, back in my back yard in Virginia, such similarities:
Both over dark pines,

 both like a half-gouged eye wherever it glares down.

<u>I KNOW IT SOUNDS STRANGE, BUT IT SOUNDS RIGHT TO ME</u>

Unless mistakes are made,
 virtue is like unto water, and
Seeps into shrunk, detested places,
Shines in its mottled pools,
 and illumines and has no desires.
How hard to identify with that.

The virtuous does not know itself as virtuous.
The great writer does not write.

AUTUMN THOUGHTS, ON THE NIGHT OF STRAND'S BOOK PARTY IN NEW YORK CITY

I've written commentaries on the wind and moon for all these years.
And what kind of enterprise is that?
Better to have cavorted with loose women,
 better to smell the stench of reed flowers.

Everyone speaks of autumn with a glaze-saddened heart.
I grind my ink thick,
My inkstone the passing seasons,
 my song a song of praise from my dawned, dark heart.

WHO SAID THE CHINESE DIDN'T KNOW WHAT THEY WERE TALKING ABOUT?

Li Po says an imperishable fame of a thousand years
Is a paltry after-life affair.
Who couldn't agree to that?

What a guy.
 The deer are beginning to congregate
In my backyard, deep in the city.
Something is happening, and strange, and about time.
 (Sweet Revelations.)

LESSON FROM LONG AGO

Stub-end of November,

 last leaves like tobacco flakes

Stuck to the lip, sundown's lip,

Exhalation of what's goodbye.

 So long to that wickedness.

Insects no longer swarm in the grass.

The first winds of winter

 stir up the horizon's end.

Someone once said that writers abhor a worldly success.

 Hmmm . . .

IF LIFE IS A NEGATIVE, WE ARE ITS PHOTOGRAPHERS
===

The sorrows of distance is all we have to look forward to,
Indolent vista.

What strips down the oak tree is not the wind,
 but inner ebbing.
What ruins our lives is what we walk on –

It takes us in in our little boxes,
 and soothes us
As we gradually seep away and pool up in the dark.

SAME SONG, SECOND VERSE

What is it about the new moon that troubles my sleep?
Neil Armstrong would know,
But he won't say.
 Sir Patrick Spens, however, knew all would come to harm.

There are no fifty fathoms here,
 and no Scots lords at my feet.
But I feel their pull, and scan the scrim
Of cloud tatters endlessly hovering overhead
 like green flies above green meat.

WHO KNOWS WHAT LURKS IN THE HEARTS OF MEN

December, the twelfth month, and public exercise, the chopping of ice
Last month, we hunted badgers.
Next month, we'll bring the ice to the storage bin,
 or else to the propane freezer.

True, I'm making this all up.
 So many centuries ago . . .
One hopes the present will last, and be the past, but it won't,
 arbiter or not.
Don't make the dogs bark.

IF I'M HERE, WHO'S THAT OUT THERE?

Trust in God, and always swim toward shore.

The rain keeps piling up,

 from the 5th to the 7th ply of heaven.
Left arm, breathe, right arm, breathe, breast stroke, back stroke,
 then dead-man's float.

How long ago that all seems.
Who was to know we sat on the hard rocks of Purgatory,
Watching ourselves be pulled in,

 watching ourselves reeled out?

THE SECRET OF WHAT'S HAPPENING

How is it we all grow emaciated in vain?
Nobody gives a damn.
 Grief, and the side arms of grief,
Are cold, but nobody gives a damn.

Kingfishers blow in the wind, but don't turn back.
 Like ancient sleeves,
They make it a part of what they do.
There's water enough in the weather,
 don't add to it, nobody gives a damn.

LOOKING OUT THE WEST-FACING WINDOW

How is it one comes to terms with life?
 One never does,
I suppose, everything getting narrower, the children drunk
And abusive, the sky breaking up but the clouds not moving.

Our lives are such common stories,
 fallen leaves on a long path.
We wait it out, I guess, counting our sins and our have-not-dones.
Immortality's for others, always for others.

THE LIGHT AT THE ROOT OF ALL THINGS

Splendor surrounds us, as Kafka says,
 invisible, and far away.
Will the right word reveal it?
Will the right name enter its ear and bring it forth like a sun?

He says you have to call, and not wait -
It's not hostile, it's not deaf.
I'd guess, if you got them right,
 it's like, when it appears, just what's in front of you,

Something inveterate, some thing indestructible.

"SEND NOT TO KNOW FOR WHOM THE BELL TOLLS, IT TOLLS FOR THEE"

No monastery bells in the high country,
 but the woods ring.
It's bell time, and twilight, and far back in the forest,
The rhythmless chime of the night gong.

And one is drawn to it, as a penitent to the temple.
No monk back there, however. Back there, the sky thunder-threaded,
The narrative our lives take is without incense,
 and silent, and growing dim.

I'LL PLANT MY FEET ON HIGHER GROUND

Well, it is late, it's late in the day, and for sure getting later.
And we're not, as Auden snided, waiting for the end,
Though the end, as sure as hell is,
 is waiting for us.

Not news, boys, not news.
Listen, let's all go down to the river.
 Let's all, just one time.
Let's all go down to the damn river, and see what they're talking about

LITTLE PRAYER

Lord of the ugly chair and the broken sofa,
 Lord
Of mouse piss and pack rat shit,
Lord of the badger bite and the pine squirrel nest,
 cleanse me and make me whole.

Shuttle my insecurity, hasten my diptych.
As the sun runs its fingernails
 against the western skyboard,
Tell me that things will be all right (that hell is no certainty.)

<u>SKY GUY</u>

These days are my days, though they do not belong to me.
And the years as well.
Each one is a gift, a gift that can't be reciprocated.

Like old friends, like white clouds, they drift on and on,
 and never come back.
No failure or success bedevils their destiny.
Let them be, dear Lord, just let them be.
 I'll pay it all back in the afterlife.

HEMLOCK

At my age, I regret I'm not able to master my own body.
At my age, I regret I can't purify myself.
One regret plus one regret makes one regret.

 The hemlock cones,
In their tiny insularity,
Dangle like parasites from their bone-feathered branches
And have no regrets, not even one.

 O, how I pity them.

CIRCUMFERENCE IS ONLY THE HALF OF IT

I scratch this poem in the dust with a tamarack stick.
Dry spring. East of me, west of me,
 everyone's growing older.
If the sun sets, I can't see it,
 cloud tags and empty ceiling.

Music comes from the trees, harmonica music, that breathy shadow.
The past puts the here-and-now to shame,
 and vice-versa.
Only the future sees them both for what they are,
 nobody noticing, people coming and going.

DOWN IN THE MINES

For I am one who exists from the undivided,
He said, and am filled with light.
And darkness is over there,

 where the divided stand.

Tough words, Ace, tough words.
White clouds grow big along the ridge line.
Under the earth we're far away from home,

 or closer to it.

BARITONE BONE

As Gerry Mulligan once said,
 You've got to know how to leave the bone alone,
Referring, of course, to making too many notes on the saxophone.

Poems have too many words,
 and not enough silence
Where words might have been.
Everyone knows what silence says, and says so eloquently.
But what do words say, what do they mean?
 Not much just noise not much.

AL DI LA DEL CIELO

Well, there is an empyrean beyond the empyrean,
A negative possibility
That knows more than it knows,
 whose light is an unendurability.

We'll never see it.
And that's all right, for God's sake.
 Who needs
Another unbearable substance,
 a pillow of post-celestial fire?

THE NIGHT WILL BE DARK AND COLD THE GROUND

Deadfall and limb-bearded tamaracks,
 the grass _in ginocchio_, creek gurgle,
Landscape on which the sun has gone down,
First smudge of shadows beginning to form,
 light still on ridge line.

Year after damped year, anxiety burns out my heart.
I know one must not say so,
But year after year, anxiety burns out my heart.

INCOMMUNICADO

I tend not to understand things,
 and think what other people think is what I think.
That's not a smooth move.
What others are thinking has nothing to do with me.

Or nothing to do, in fact, with the rings of Saturn,
Detritus of some
Celestial end-game
 drifting untouched across time.

WELL, THE CUCKOO IS A PRETTY BIRD

Northwestern sky after rain -
 clouds of uncertain heritage
Moping down east, their outfits in fuzzy disarray,
Their tracks still warm from last night's lightning.

And where's their huge, invisible engine pulling them
This scattered, encroaching afternoon?
Like us, I guess, into dissolution,
 like us, elsewhere, into the raven claws of the wind.

ALL CHANGE IS GOOD, ALL CHANGE IS BAD

Horses let out. Mare's tail sky
In the west, Destroyer quivering his thunderbolts
Over the cloud-clotted Pacific and moving in.

Meanwhile, we hitch our pants up
And envy the weeds, their one cheek to the wind, their other to the da
And envy their silent acceptance,
 affection for whichever one comes first.

WELL, I STILL HAVE MY TEETH, AND THAT'S NOT NOTHING

Autumn. We're still like foxfire,
Flitting and flailing, on and off,
 pinpoints of light, and the night is deep.
At seventy, this life is rare, and has been since time began.

In these late years, I'm only drawn to the stillness.
White clouds drift on and drift on.
In pairs, the birds return to the privet hedge.
 The darkness there is their living room.

Charles Wright was born in 1935 in Pickwick Dam, Hardin County, Tennessee, and grew up in Tennessee and North Carolina. He attended Davidson College, The University of Iowa, and the University of Rome. From 1966-1983 he was a member of the English Department of the University of California, Irvine. Since 1983, he has been a Professor of English (since 1988, Souder Family Professor of English) at the University of Virginia. The author of twenty-six books, has won the National Book Award and Pulitzer Prize, among others.

Eric Appleby is the co-founder, publisher, and designer of *Forklift, Ohio: A Journal of Poetry, Cooking & Light Industrial Safety*, which is now in its 16th year of publication. He lives in Cincinnati with his wife, Tricia, and American Bulldog, Knuckles.